Kitty Love

Line &
GRAYSCALE ART
COLORING BOOK
For Children

By Cheryl Korotky

The World of Enchanted Imagination

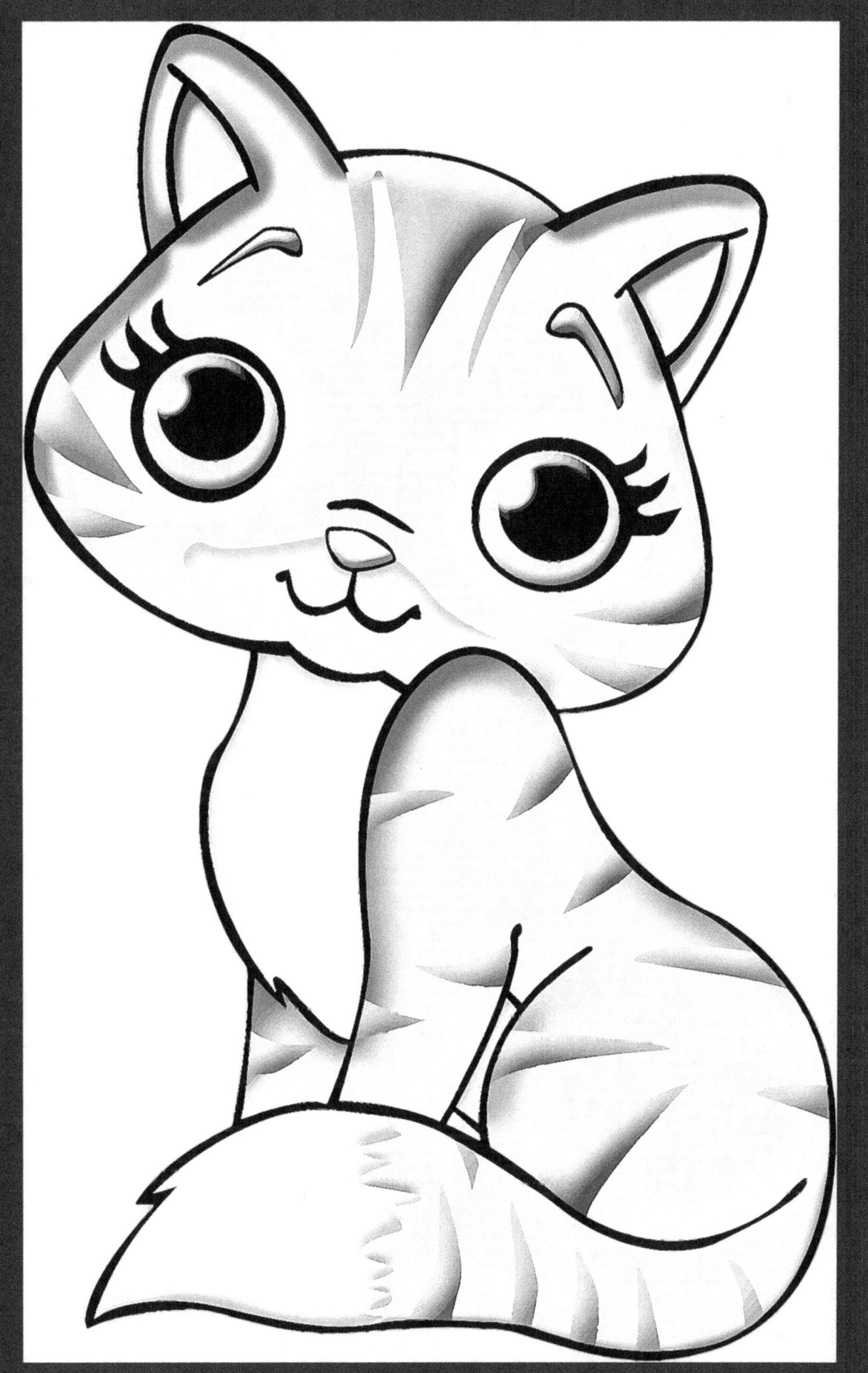

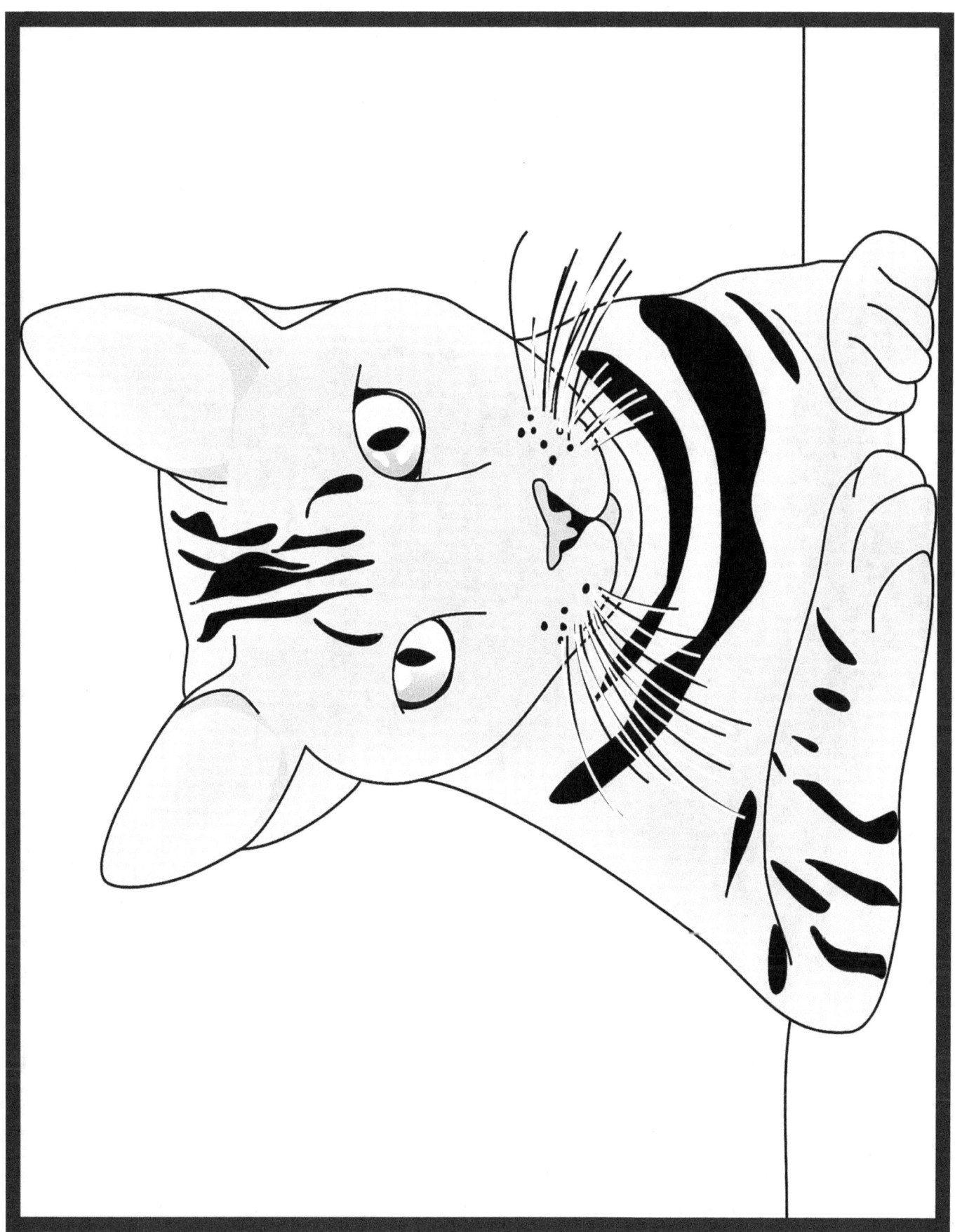

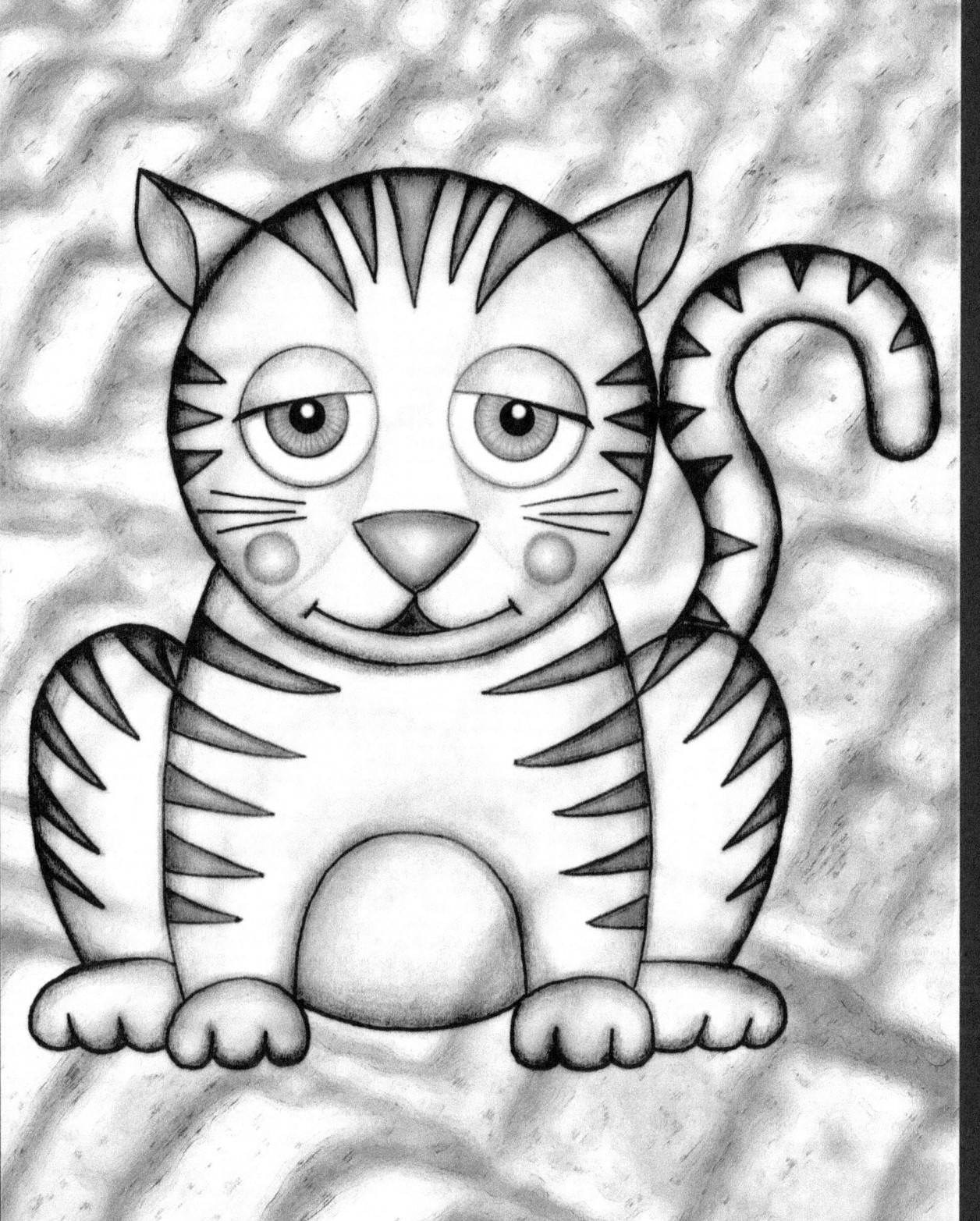

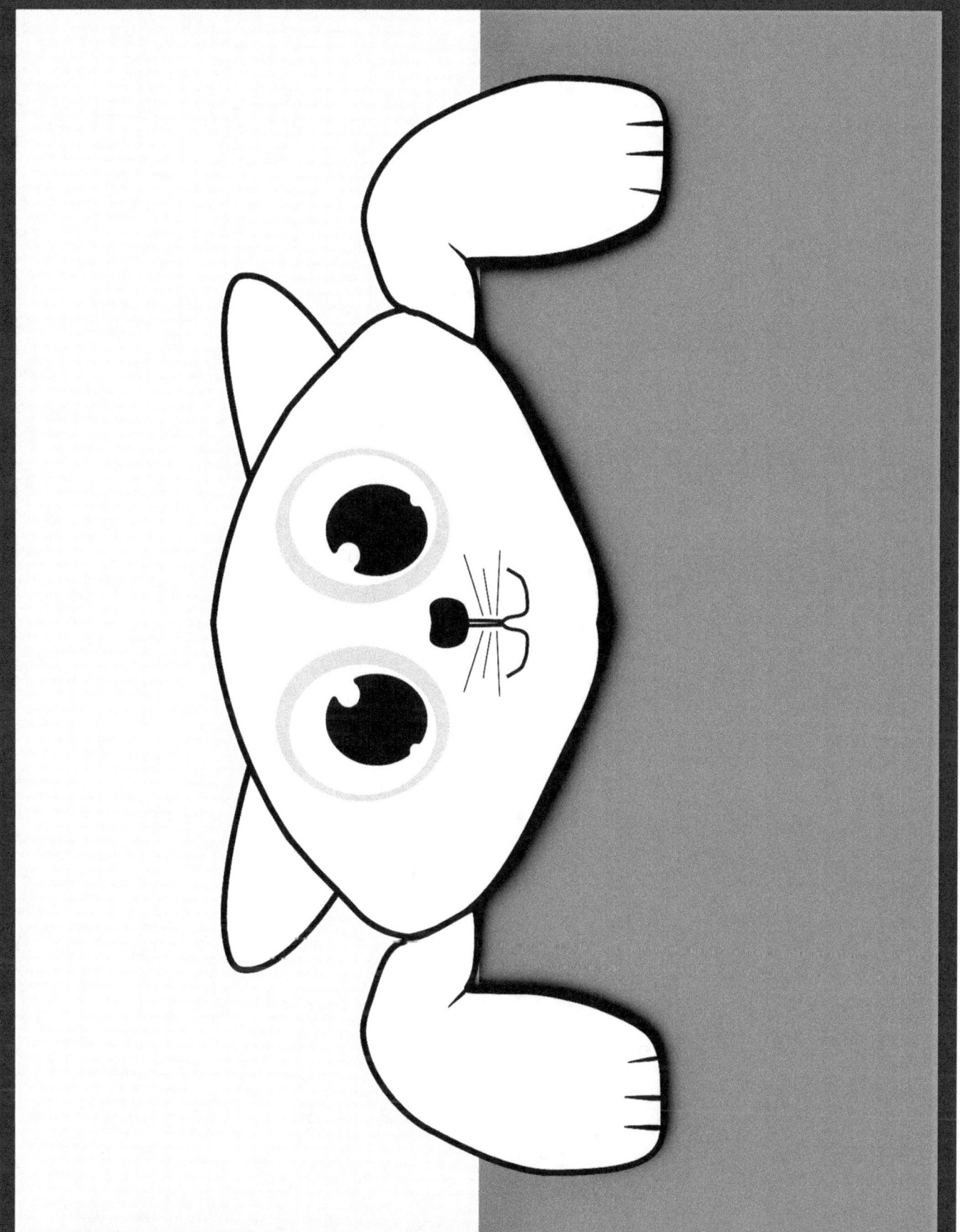

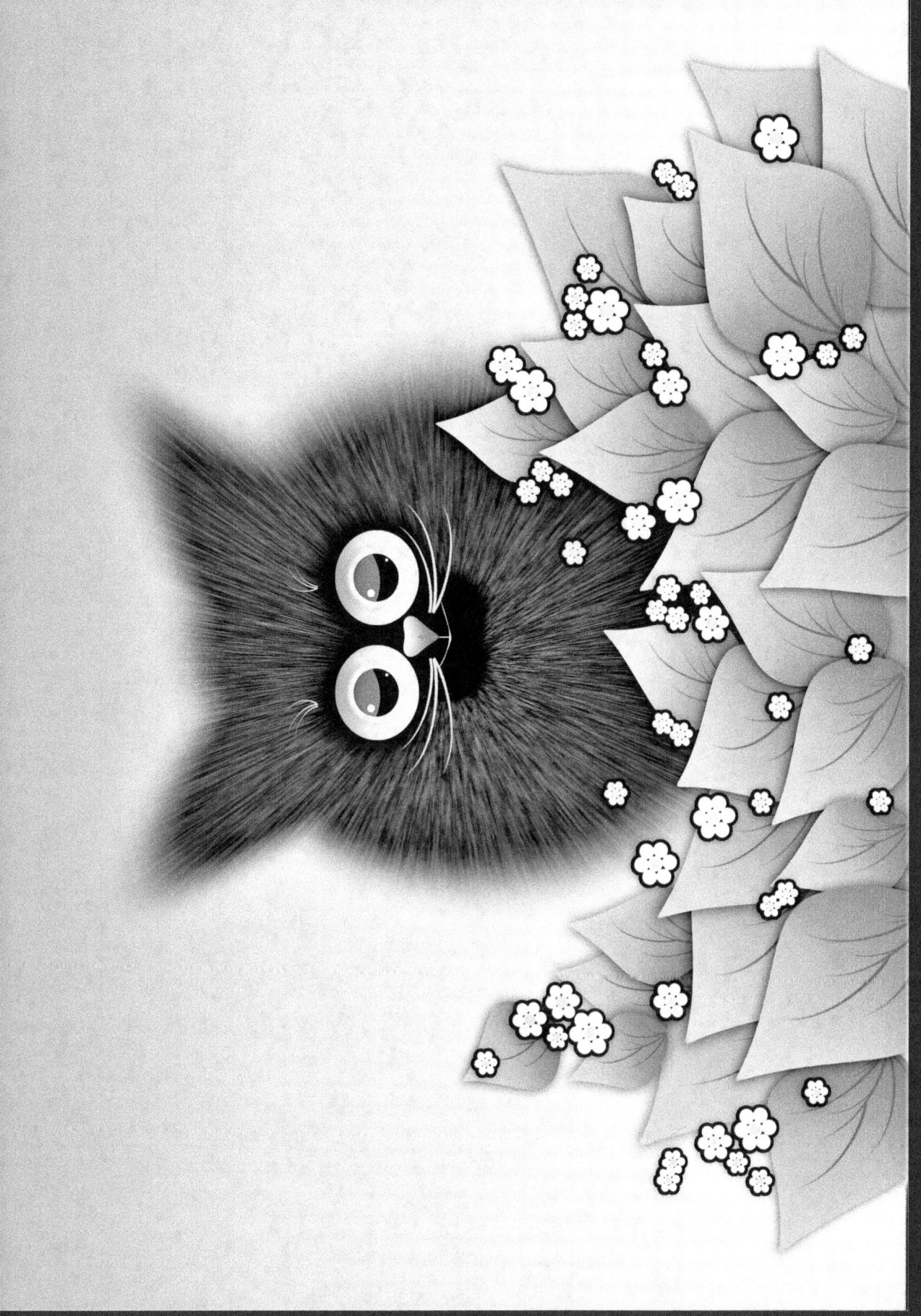

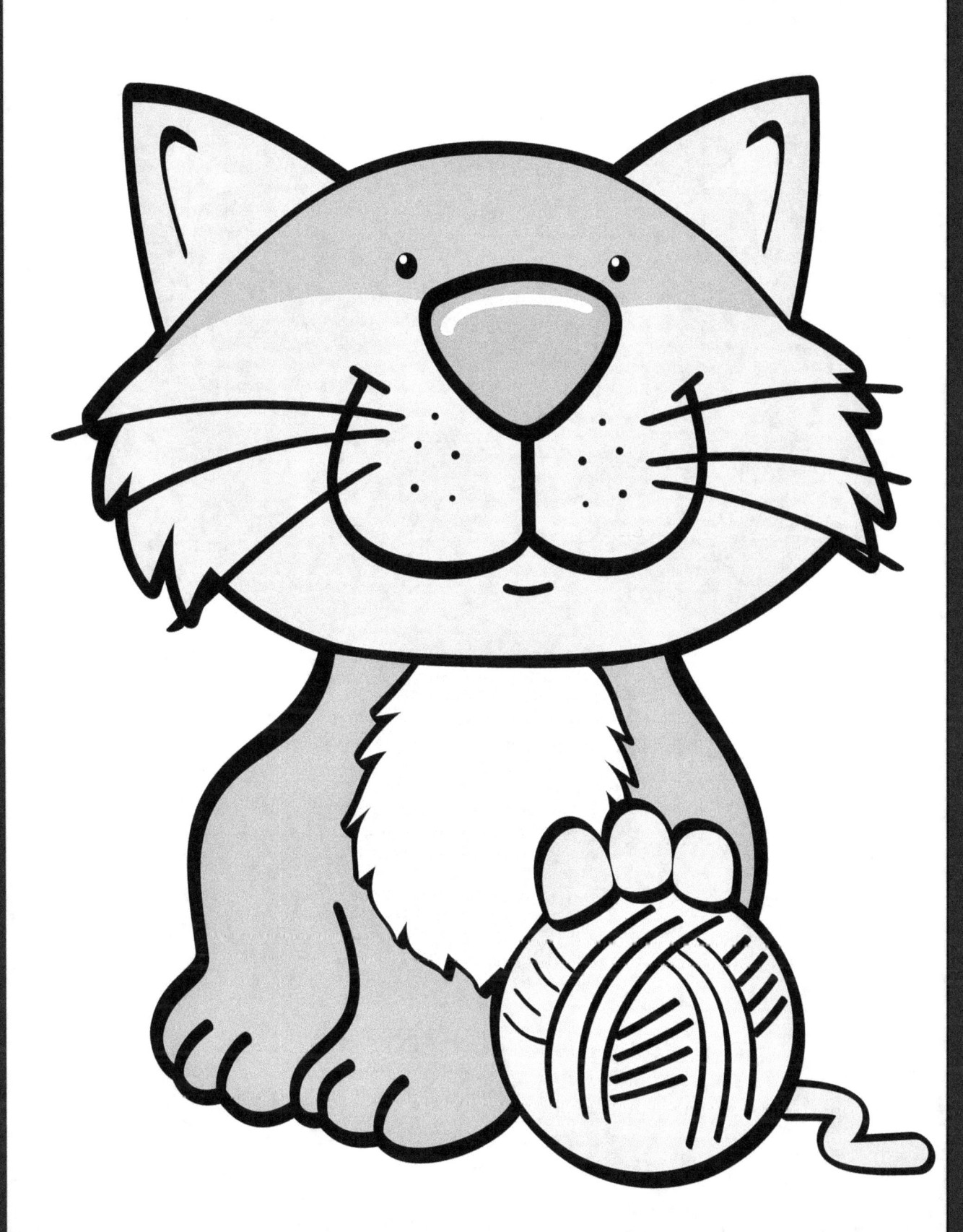

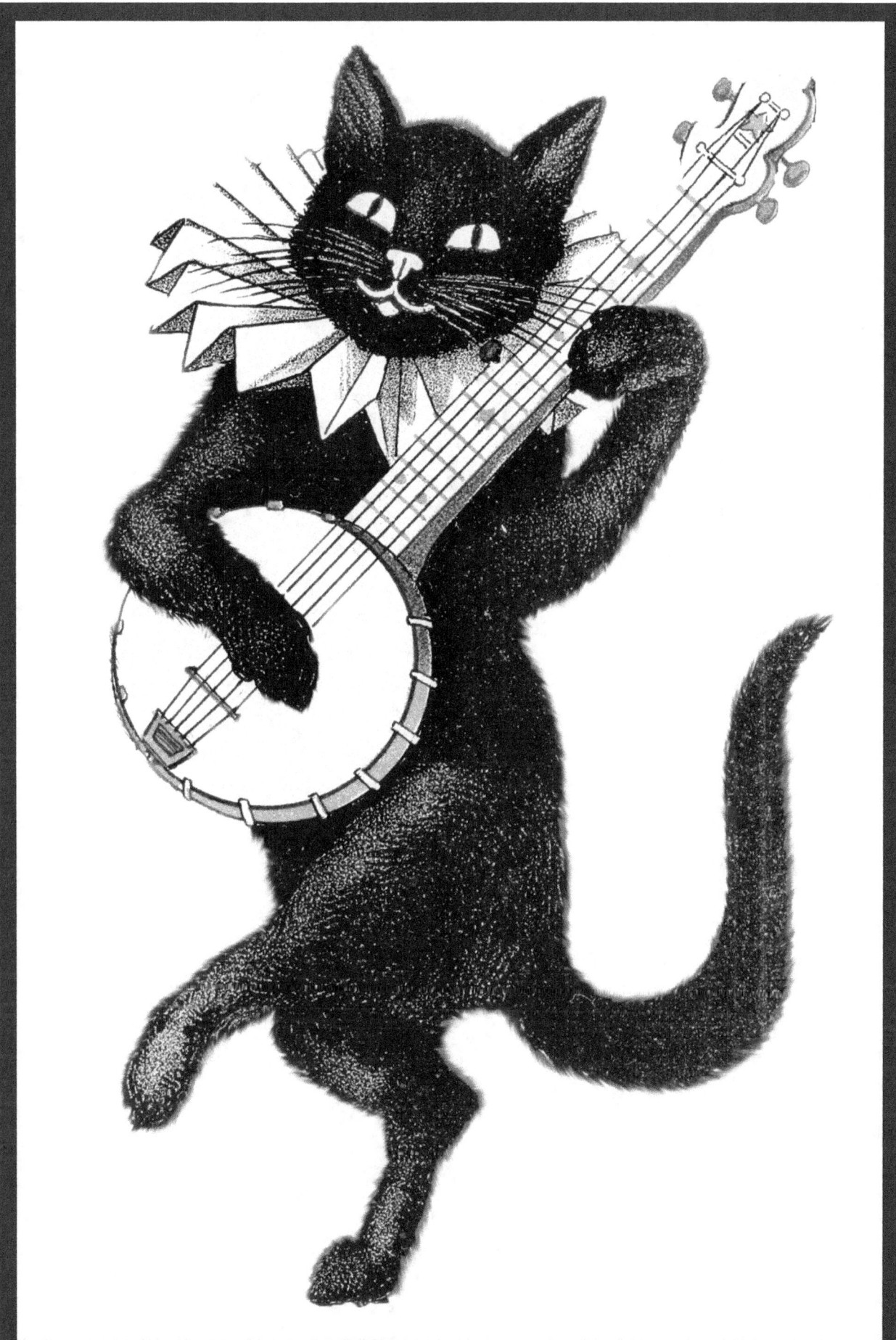

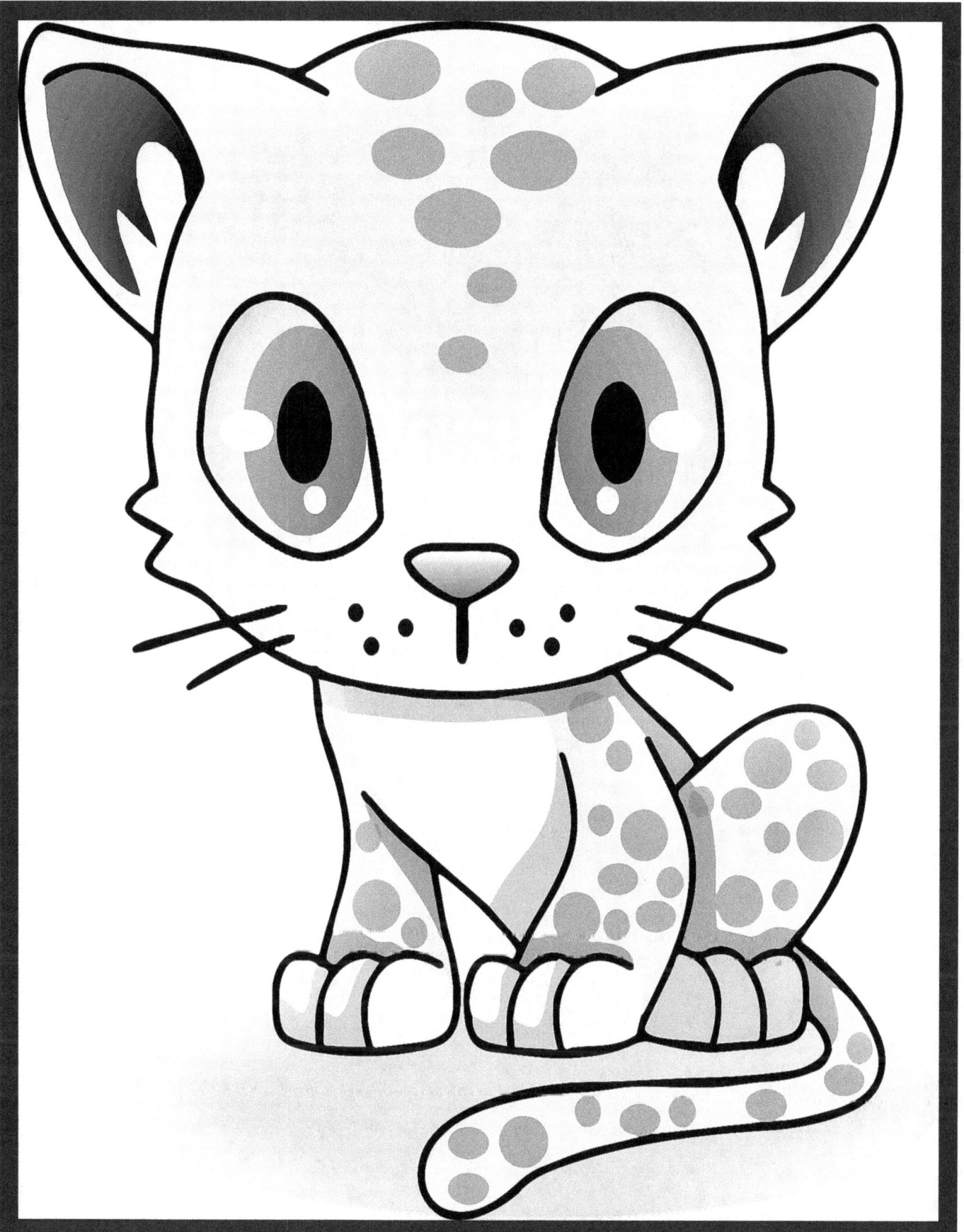

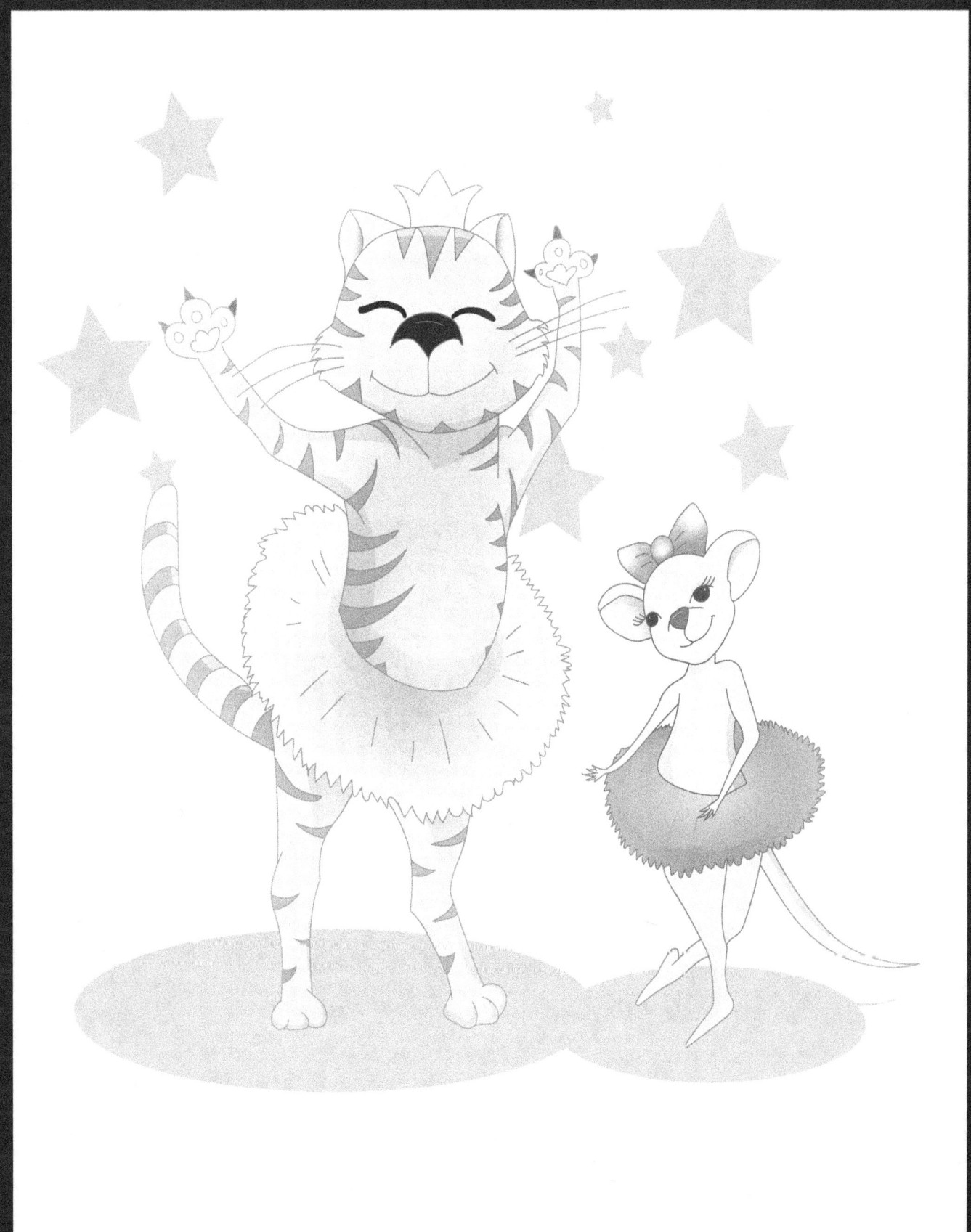